Matthew Hilton:
Furniture for our time

By Catherine McDermott

Edited by David Dewing
With additional research by Hilary Beyer

With contributions from Enrico Astori, Dinah Casson, Sheridan Coakley, Sir Terence Conran, Jane Dillon, Rasshied Din, Tom Dixon, Marcus Field, Konstantin Grcic, Geoff Hollington, Hans Maier-Aichen, Seth Stein, Paul Thompson, Michael Warren, Christopher Wilk and Gareth Williams

Lund Humphries Publishers, London in association with the Geffrye Museum, London

First published in 2000 by
Lund Humphries Publishers
Gower House
Croft Road
Aldershot
Hampshire, GU11 3HR

in association with

The Geffrye Museum
Kingsland Road
London E2 8EA

on the occasion of the exhibition *Matthew Hilton: Furniture for our Time*
at the Geffrye Museum 15 February – 25 June 2000

British Library Cataloguing in Publication Data
A catalogue record for this book is available from the British Library.

ISBN 0 85331 807 7

Distributed in the USA by
Antique Collectors' Club
Market Street Industrial Park
Wappingers Falls
NY 12590
USA

Designed by Sally McIntosh and Mark Foster
Made and printed in Great Britain by
BAS Printers Limited

The authors and publishers wish to thank all the contributors and
manufacturers who have generously provided contributions or who have
given permission to reproduce works. Particular thanks go to Lesley Dilcock.

contents

In the captions to Matthew Hilton's works, the largest dimension has been provided in all cases.

Dedicated to Margaret E. Hilton (1926-1999)

foreword

The Geffrye Museum was founded in 1914 to inspire and raise the standards of design in the East London furniture industry. At that time the neighbouring streets of Shoreditch and Bethnal Green were teeming with cabinet makers, upholsterers and French polishers, every spare basement, garret and back yard was given over to cramped workshops, and the main roads were lined with lofty warehouses where the furniture was assembled and finished ready for sale or export. The Geffrye provided first-hand encounters with genuine Queen Anne cabriole legs and Sheraton chairs and, in the spirit of the Arts and Crafts Movement which prompted the museum's foundation, it encouraged new ideas based on past traditions.

As the industry moved to the suburbs the museum shifted its focus to domestic interiors, with its collections displayed in a series of period rooms which show the changing style of urban, middle-class interiors from 1600 to the present day. A new extension designed by Branson Coates provides a gallery for twentieth-century interiors, where the room for the 1990s is based on the recent trend for lofts in converted warehouses, such as, ironically, the very same warehouses in Shoreditch built in the nineteenth century for the furniture industry. In our research for this display, it became clear that Matthew Hilton's furniture, the Balzac chair and Flipper table especially, were already firm favourites for the loft type of interior and were frequently selected by the media as typical of the style.

I first met Matthew in 1992 or 1993, not long after I had come to the Geffrye as Director. His Antelope table in particular had already attracted my attention and his subsequent work has retained that quality of quiet assurance and close attention to detail. He clearly understands the materials and processes of manufacture, so that structurally his furniture works and will stand the test of time. In many ways it expresses the qualities associated with classic English furniture, but in forms which are undeniably modern. His upholstered pieces are essentially sculptural and their simple, soft shapes combine to produce furniture which is welcoming and easy to live with. Although it is too simplistic to suggest that any one style of interior or any individual piece of furniture might typify an era, some of Matthew's works are already vintage 1990s, and the Balzac and Flipper are fitting additions to the Geffrye Museum's collection of English furniture.

It is fitting, too, that the Geffrye should choose to mount the first solo exhibition
of Matthew's work, in celebration of his achievement as a British furniture designer
whose reputation both here and abroad is growing with each new project. The
launch in 1999 of his all-plastic chair, Wait, heralds his entry onto a larger stage
and hints at exciting prospects for the future, and I hope this book and the
exhibition will bring his work to the attention of a wider public.

David Dewing
Director, Geffrye Museum

introduction

As a child there was something about all that post-war stuff that affected me, a sort of left-over feeling from the war of objects that had survived from the 1930s mixed in with the 1950s. People were still not used to having money and somehow for me that made the relationship of design to real life more interesting. I would like my work to fit into the mish-mash of what people's lives are really like. I like the thought that the things people randomly acquire, hand-me-downs or junk-shop finds, get mixed up with my furniture. I'm interested in distortions, contradictions and imperfection. I still feel an empathy towards the culture of post-war design in Britain, with the designer a kind of amateur, but fighting for a cause. Those social beliefs have gone. Now, design is fashion and style.

Matthew Hilton

environment Kingston developed at this time. Kingston graduates secured key jobs in Milan with Sottsass and Olivetti, while those from the fashion school were in demand at the centre of the fashion industry in Milan, New York and Paris. For these graduates, there was a sense of being in a kind of club, a Kingston club of contacts and support which was also to help Hilton.

Early careers in design often need financial underpinning and, back in the 1970s, part-time teaching offered not only that but also memorable encounters with the next generation of designers, many of which developed into friendships.

For all sorts of reasons Kingston Polytechnic was riding high during this time: it was a vintage period and everyone who was part of it – including the staff – was enriched by it. For some it was their peak time as designers, which is not unusual. For others, Matthew included, it was used as a formative, exploratory beginning to a fruitful career.

My memory of him as a student was a white T-shirt and jeans, and him rarely finishing anything; but because the ideas were always interesting and uncompromising, he somehow got away with it, maybe by the skin of his teeth. Since then he has finished quite a lot – and of remarkable quality. This is written before the work has been collected together and I look forward to seeing it – the experience will inevitably affect any assessment. But I suspect that what we will see is work which is strong and confident, beautifully proportioned and which uses technology to support a more important idea rather than as an end in itself. I am fairly sure that it is not self-indulgent, that it is sensual, that it cares for its user and that it is very modern.

Dinah Casson, Interior Designer and Tutor

As a student Hilton was more interested in sketching than technical drawing or model-making. Even now, he has to force himself to produce the finished technical drawing; it is the part he likes the least. Freehand drawing and thinking through drawing and models remain his preferred methods of design. His 1979 degree show was an important turning point for him. Inspired by the architecture of the late 1970s, such as the Pompidou Centre by Richard Rogers and Renzo Piano, Hilton explored the possibilities of making simple structures for furniture which questioned traditional methods of construction. His Tension table attracted early press interest, featuring in the legendary British style magazine *Viz* and in *Architectural Review*. It also came to the attention of Joseph Ettedgui, a man whose impact on fashion retailing was to be revolutionary.

13

Hilton's first job was with an industrial design company called Capa, based in London, producing plastic cases for an early generation of personal computers, the Apricot. This was technical design involving injection-moulding and model-making and it taught Hilton a practical, hands-on approach to design which was to become his hallmark. There was little opportunity for his creativity, however.

In the course of one's career as a design lecturer one can probably count on one hand the students who exhibit a true potential for greatness. In my case, Matthew Hilton would count as one such student. Whilst at college Matthew had been adventurous with materials and also found a very personal and engaging slant in the resolution of problems. Although at this time much of his focus was on the 'one-off' rather than on mass-production it seemed inevitable that, as soon as his interest focused on this part of the market, interesting outcomes would be inevitable. When he left College he had a lot of unresolved ideas to explore and clearly had not reached his full potential, a full potential that I think we are only now realising.

Michael Warren, Course Director, Kingston University

14

In 1983 Hilton designed a collection of cast aluminium bowls and candlesticks, which he described as 'sculpture with a purpose'. Inspired by the new spirit of Punk and shops like Ben Kelly's Seditionaries in the King's Road and The Last Resort in Whitechapel, young designers were beginning to feel they could do without manufacturers, that they could simply make their own work. A number of them, including Ron Arad, Tom Dixon and Danny Lane, did just that, producing furniture which was exciting and raw and not afraid of showing the making process. Their work expressed an approach to design in the 1980s which, within the European design scene, was unique to London. Matthew Hilton took a slightly different route, however; it was not in his nature to become a designer-maker. Like his contemporaries he was interested in metal as a material but his approach was less rough, more polished and potentially more mainstream. He wanted to make simple objects that offered him freedom in sculptural terms, using aluminium as a low-cost but modern material. The first piece was the Oval bowl.

He kept control of the making process, carving his own models in wood or forming them in fibreglass with moulding resin and car-body filler. The patterns were sand-cast in aluminium and polished, a low-cost but labour-intensive technique suited to small-batch production. In 1984 he started to work with Nick and Sue

Townsend's company, Essex Replica Casting, near Woolwich, in South-East London, forming a close working relationship which still continues. Initially he sold to friends, but soon found outlets in high-profile design shops such as Joseph, Liberty, Conran and Oggetti in London's Fulham Road. The collection sold well and aroused British and international interest in his work. It also attracted commissions for furniture from private clients such as Bruce Oldfield, Liz Tilberis, then the editor of *Vogue*, Jasper Conran, Paul Smith and Pamela Hanson, the fashion photographer for the Joseph shops. His relationship with the fashion retailer Joseph was particularly strong and in 1985 an exhibition of Hilton's designs was installed for the opening of the Joseph Pour la Maison shop in Sloane Street, London.

During the mid-1980s the world of design was burgeoning in London and retail work was flourishing. The new wave of interior design practices such as Rasshied Din employed Hilton for his personal, idiosyncratic touches for projects like Next's flagship store in Kensington High Street, London. More importantly, however, his path crossed with Sheridan Coakley, whose shop SCP, in Shoreditch, East London, then a run-down area of dilapidated furniture warehouses and factories, was to become one of the most interesting outlets for British contemporary furniture.

15

As one of the few retailers commissioning new British furniture, Sheridan Coakley has come to play an increasingly important role in the history of British design. He began as a specialist retailer of 1930s tubular steel furniture, re-plating and reproducing designs by Pel, a British company well known for its modernist furniture in the 1930s. For the metalwork Coakley used Electra Plating, a company in Shoreditch, and one of the last surviving remnants of the East End furniture industry. His desire to move from the old to the contemporary inspired him to organise the first UK exhibition of Philippe Starck's work, then little known outside France.

In 1986 Coakley took the radical decision to produce a collection of contemporary tubular steel furniture designed by Jasper Morrison and Matthew Hilton. This included the Bow shelves, the Trolley and Big Leggy, a glass-top table. Both designers relied on Electra Plating's manufacturing skills and experience to make the range. There was an element of making do with limited resources but the results were sophisticated and surprisingly fresh. The furniture reflected a continuity with the 1930s, offering an interesting alternative to the 1950s Italian design route explored by the Memphis group. Coakley took the collection to the Milan Furniture Fair where it attracted a great deal of media attention.

The catalogue, designed by Peter Saville, with photographs by Trevor Key, became a design classic in its own right. In the mid-1980s, SCP's Milan stand was one of very few British contemporary design events seen in a European context. Milan also secured SCP their first order from the Conran Shop. Priscilla Carluccio, Conran's sister and legendary buyer, liked what they were doing and was generous and supportive to this young company. Gradually Hilton's Bow shelves became SCP's first commercial success.

16

Matthew was one of my students when I was teaching on and off at Kingston Polytechnic in the late 1970s (now Kingston University). This may have been the birthplace of contemporary British furniture design as Jasper Morrison and James Irvine were also there at that time. I remember Matthew's matter-of-fact confidence and enthusiasm; I liked him a lot, he asked a lot of questions. When he started getting his stuff into the magazines and stores in the 1980s, I was a bit sceptical about the candlesticks and shelves and so on which, to me, seemed a bit obvious, a bit too easy. Then he did that wonderful, best-selling coffee table. Like several of his peers, Matthew is now working with mainstream industrial processes, courtesy of overseas clients of course. It is tragic that this couldn't have happened ten or fifteen years sooner, but without any serious manufacturing in this country, all the battles have to be won offshore. I like the way his products seem to be getting simpler, cooler and more iconic, probably driven by the pragmatics of tooled-up manufacturing. Personally, I'd like to see him break out of furniture into some product design, soon.

Geoff Hollington, Product Designer and Tutor

This metal furniture from the mid-1980s established Matthew Hilton as an important talent. The Antelope table with its distinctive animal legs was designed at this time, directly inspired by David Smith's sculpture, but it also marked a significant change of direction for Hilton. He felt that this sculptural approach was not working for his furniture, at least not without compromising practical considerations and manufacturing concerns.

In the recession of the late 1980s the contract furniture market slumped, while in the 1990s the retail market for contemporary design started to develop. SCP began to focus on furniture for the home, particularly upholstered furniture and furniture made in wood. Coakley wanted designs that signified quality and longevity, products such as a traditional drop-leaf table updated for the 1990s. The designer

who he felt understood this agenda, and the technical aspects of batch-produced, traditionally-made furniture, was Matthew Hilton. Hilton looked to Shaker furniture for inspiration on how to use solid timber economically and designed his series, including the Britten and Auberon tables and the Byron bed, to combine a classic quality with contemporary style.

In 1989 Sheridan Coakley suggested Hilton should design a club armchair, as a play on the British tradition of the gentlemen's club, the private, comfortable and masculine interior. Hilton's first prototype was completed in 1990 and shown in Milan the following year. Named Balzac after the French novelist, its sculptural shape and deep seat looked different, even a touch curious when it was first shown. Sir Terence Conran declared it the best example of upholstery design he had seen for years. Although sales were slow initially, the Balzac's appeal has crossed barriers, and it can now be found equally in homes, executive offices and airport lounges. Hilton's upholstered furniture is developed through a process of co-operation and collaboration with SCP and Thetford Design, a small Norfolk firm run for the past twenty years by John Young and Bruce Allen, where the furniture is made by hand from wooden frames, sprung seats and traditional upholstery. With their help Hilton developed a close understanding of the techniques of upholstery and a special skill in upholstery design. This partnership between SCP, Thetford and Hilton has produced over twenty products to date, from the Orwell and Kerouac sofas to the Club armchair and the metal-frame Easy chair.

17

Hilton's success with SCP brought him to the attention of other potential clients, attracted by his attention to detail and his ability to distil existing classics and make of them something contemporary. At the end of 1995 he was contacted by Enrico Astori, managing director of Driade. One of Italy's premier design companies, Driade has an enviable reputation for cutting-edge chic and style. Their stable of fashionable designers included Philippe Starck and Borek Sipek and they wanted a British designer. Astori offered Hilton a unique opportunity to design five upholstered pieces in injection-moulded foam, a manufacturing process new to Hilton, which allows greater freedom of form than traditional upholstery. The resulting furniture was, in Astori's words, 'organically futuristic, yet familiar' and these important Driade pieces represented for him 'the organic soul of British design'.

Hilton went on to work with other European clients. For some time he had been thinking about filling a gap in the market between the plastic garden chairs of the type sold on garage forecourts and the expensive designer versions such as the

Maui chair by Vico Magistretti, produced by Kartell. Hilton set out to design a good-looking plastic chair which would stack six high and sell cheaply, and in 1997 he approached the German company Authentics, run by Professor Hans Maier-Aichen. Authentics had started as Artipresent, a company which made decorative interior accessories, and Hans Maier-Aichen was given the task of changing its image. It was his idea to make moulded plastic look translucent, more like frosted glass in the way it played with light. Plastic was being taken seriously as a design material in a range of interesting, well-designed objects, and although Authentics specialised in domestic utensils, not furniture, they were interested in Hilton's idea and gave him the go-ahead. The result was the Wait chair, launched in 1999. Hilton's eye for refinement and detail produced a design classic which has become an immediate success, with over 3,000 ordered for the Millennium Dome in London and a new market created within the furniture trade for low-priced, high-style plastic chairs.

The Wait chair, low-cost, accessible and stylish, has brought Matthew Hilton to the end of the millennium with some thoughts on future directions. 'What I continue to think about is the way people really live. Not many people's homes resemble a spread in a style magazine. I'm interested in making things that fit into the kind of spaces we actually live in. Furniture for lots of different kinds of people. People should have products for their future.'

Matthew Hilton's work has a sensitivity to the domestic landscape that makes it highly appropriate and pleasurable. It is quintessentially English. As a contributor to our culture his work is refreshingly free from the dogma of the Modern Movement, a position that very few contemporary designers inhabit.

Jane Dillon, Furniture Designer and Tutor

Tension table
1979
Glass, metal, wood
190 cm
Manufacturer: Hilton
Photo: Marcus Hilton

metal

I have always thought of metal as a material of the Modern Movement. Chromed steel is the predominant material of modernist furniture design. Designers who used bent tubular steel produced cool and sleek objects which were viewed as icons of mechanisation: Marcel Breuer (Cesca B64 cantilever chair 1928); Mies van der Rohe (Barcelona chair 1929); Le Corbusier with Charlotte Perriand (*Grand Confort* 1928). I found I was excited by the work of the sculptors of that period like Constantin Brancusi whose deceptively simple but highly sophisticated and sensual forms spoke of very human and basic ideas. The rough and earthy, sometimes violent work of the sculptor Giacometti seemed to me to draw our attention to the difficulties of the human experience.

22

[right]
Alberto Giacometti
Woman with her Throat Cut
1932, cast 1940
Bronze
Courtesy of National Galleries
of Scotland

[opposite]
Harry Bertoia
Diamond chair
1950-2
© Fiell International

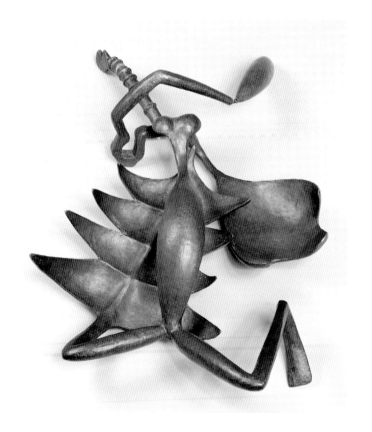

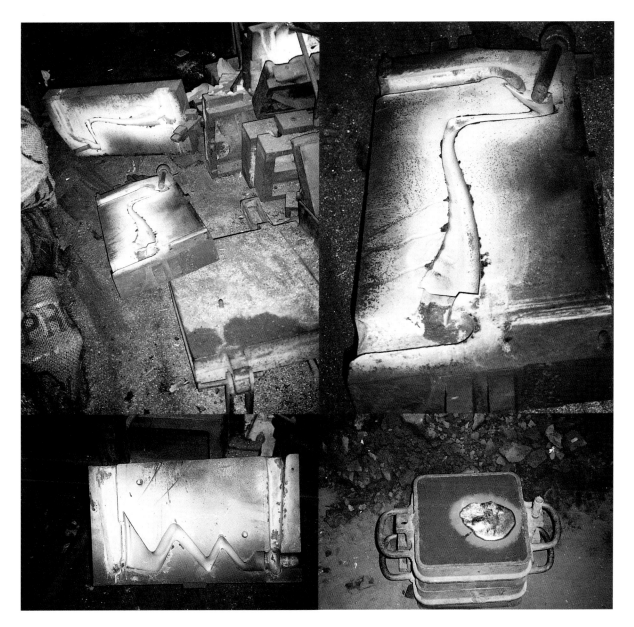

Gareth Williams
Assistant Curator, Department of Furniture and Woodwork,
Victoria and Albert Museum

'Simple', 'modern' and 'traditional' are words that Matthew Hilton regularly uses about his own work. 'Most of the furniture in the world has been made the same way for years and years. You don't have to be revolutionary all of the time', he has said. His humility betrays a peculiarly English reserve, as well as a respect for the past. Matthew has an understanding of traditional English furniture types and methods of construction that gives his furniture a lasting appeal. He uses wood, traditional upholstery, leather. He designs club chairs. Although I was surprised when Matthew once told me he knew little about William Morris, perhaps his avowed modesty about design history is just another example of English reserve.

This is not to say Matthew's furniture is not contemporary, as it has most certainly come to define a certain aesthetic in the 1990s. The famous, almost iconic Balzac chair hints at smoky Pall Mall club libraries but non-specifically, which makes it equally at home in Shoreditch lofts. As a designer he is not a slave to fashion, even though the furniture market, in which he is now a star, is increasingly as heated and as cyclical as the fashion world. His early furniture often incorporated animal-inspired brushed aluminium elements and details that launched a high-street vogue in the late 1980s, and which is also a distinctive feature of much work by his French counterpart Philippe Starck. Like some Starck furniture, Matthew's Antelope table alludes to French Empire furniture of the early nineteenth century. The Victoria and Albert Museum collected an example to show the exuberance and vitality of late 1980s furniture. More recently, he has simplified his designs for mass-production and distribution, most notably his Wait chair for Authentics, a reworking of another traditional type, the 'garage forecourt' patio chair. This chair is also Matthew's move into designing high volume plastic furniture, but it bears his distinctive, coolly sophisticated, never brash style.

Some contemporary furniture is designed for magazine pages, for collectors and for contemplation in galleries. I have never felt that Matthew Hilton designs with an overt 'agenda' or 'concept'. He designs furniture for use in real situations over time, which is of its time but not tied to it. I don't think he sets out to design classics, but by concentrating on creating the most lasting forms from the best materials, he may succeed in doing so.

26

Antelope table
1988
Sand-cast polished aluminium legs; stained sycamore leg;
Stained MDF top and stainless steel disc
85 cm diameter
Manufacturer: SCP
Photo: Trevor Key

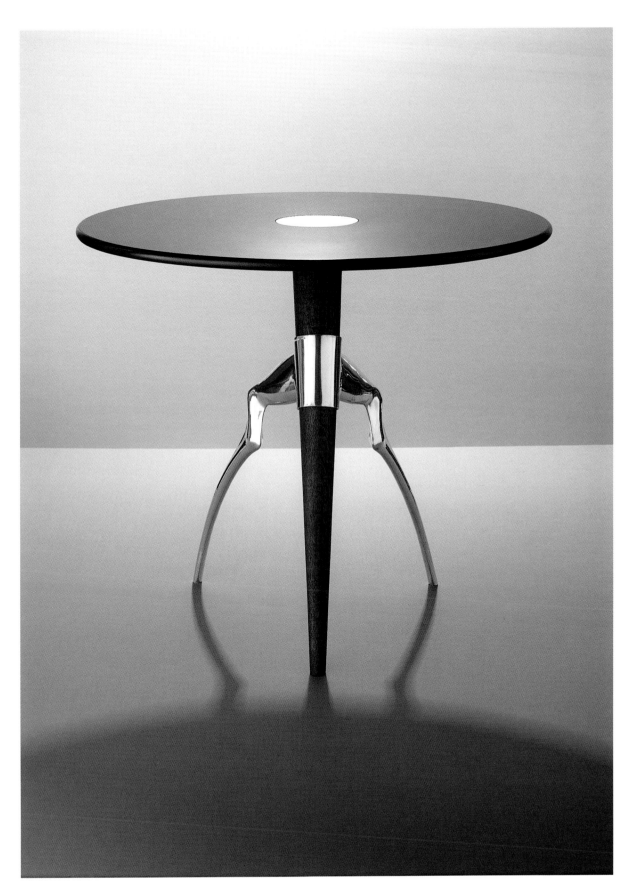

Rasshied Din
Interior Designer

Brancusi candlestick
1985
Sand-cast polished aluminium
64 cm high
Manufacturer: Hilton
Photo: Trevor Key

Flipper table (rectangular)
1987
Die-cast polished aluminium
and glass
117.5 cm
Manufacturer: SCP
Courtesy of SCP

I've known Matthew since the mid-1980s and worked with him on several occasions. In 1987 Matthew came into Din Associates as a visiting freelance designer helping us to design the Next Kensington flagship store which opened in 1987. I was impressed with his contribution because he brought a specific style yet never allowed his view to dominate the overall effect. He understood our aesthetic and quickly settled into the office and became part of the team. He is both charming and easy-going which endeared him to everyone he worked with. I could depend on Matthew to give an interesting dynamic to the team, creating solutions which were well conceived, thought through, and in his own inimitable style. His work is calm, beautifully detailed, contemporary and yet ultimately appropriate.

His work is not 'trendy' in avant-garde terms which, as a designer, makes it easier for me to specify. It is accessible, yet it has a character and personality. My favourite pieces are his anthropomorphic works where animal forms and human functions merge together. I own several pieces of Matthew's work. He was the first designer I knew to design and make home accessories in cast aluminium and copper. His candlesticks, vases and tables were ground-breaking and many of his ideas were taken up by his contemporaries.

29

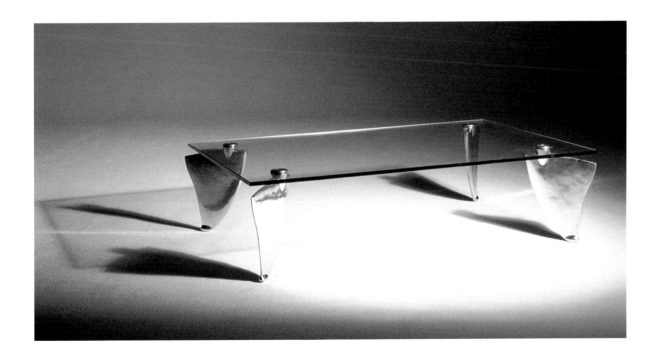

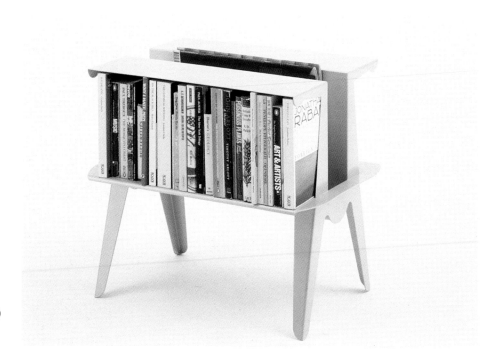

Konstantin Grcic
Furniture, Product and Lighting Designer

I met Matthew through SCP in 1990 when he was a 'big guy' and I had just
finished my studies at the Royal College of Art. He was already quite well known
and so naturally I looked up to him. At that time he was working on a series of very
distinctive projects in cast aluminium: the candlesticks with a Brancusi influence,
the Antelope and the Flipper tables. What particularly draws me to his work is its
sculptural quality. He has a remarkable ability to work with volumes which he
moulds or carves into particular shapes. This involves a good eye and tremendous
skill which is why I admire his work so much. It may be quite different from my
own, but I feel attracted to it because I am sure that we share many of the same
principles in thought. One thing that comes to mind when I think about Matthew
is his beautiful character. He is humble, but always direct and he has a consistency
which is very special. He truly deserves all the attention he is getting for his work
although his personality may not seek the spotlight naturally.

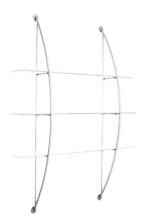

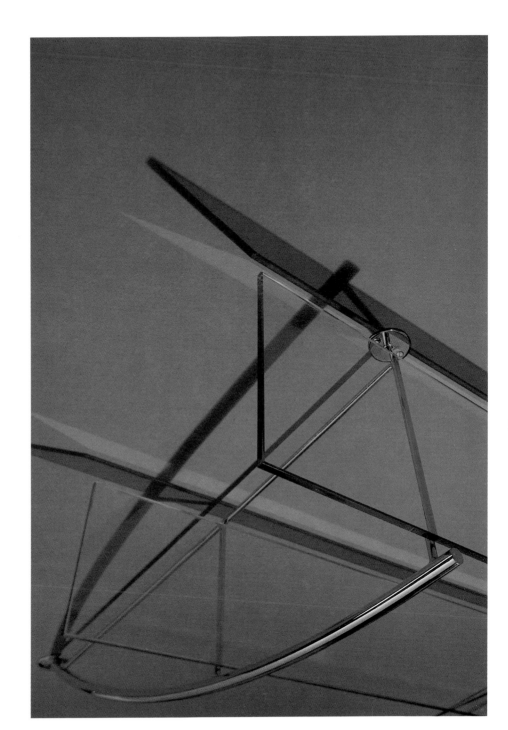

[above]
Bow shelves
1985
Tubular steel and glass
204 cm
Manufacturer: SCP
Courtesy of SCP

[right]
Half Bow shelves (detail)
1985
Tubular steel and glass
105 cm
Manufacturer: SCP
Photo: Trevor Key

[opposite]
Presshound
1997
Folded sheet aluminium
53 cm
Manufacturer: SCP
Courtesy of SCP

[top left]
Oval Bowl
1984
Sand-cast polished aluminium
69 cm
Manufacturer: Hilton
Photo: Trevor Key

[top right]
Zig Zag candlestick
and Anchor candlestick
1984-5
Sand-cast polished aluminium
30 and 37 cm high
Manufacturer: Hilton
Photo: Trevor Key

32

[below left]
Bowl with stand
1986
Sand-cast polished aluminium
62 cm
Manufacturer: Hilton
Photo: Trevor Key

[below right]
Round dish
1986
Sand-cast polished aluminium
54 cm diameter
Manufacturer: Hilton
Photo: Trevor Key

[opposite]
Swan candlesticks
1987
Sand-cast polished aluminium
45 and 39.5 cm high
Manufacturer: Hilton
Photo: Trevor Key

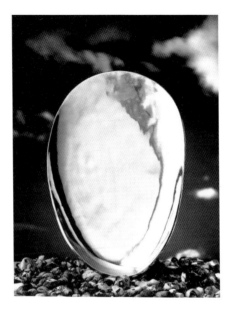

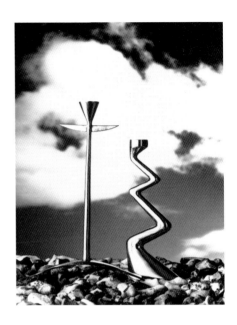

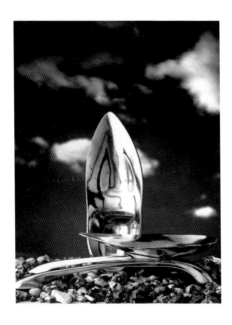

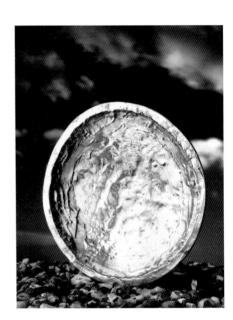

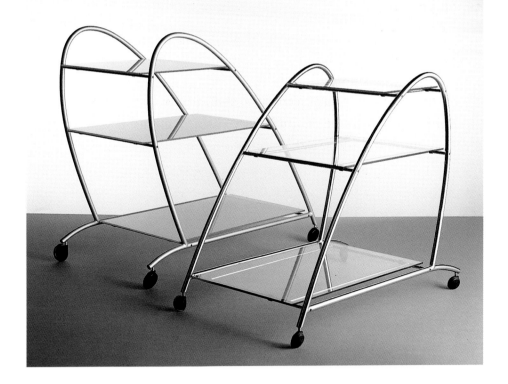

Trolley
1985
Tubular steel and glass
80 cm
Manufacturer: SCP
Photo: Trevor Key

35

Matthew deserves to be up with the world's leading twentieth-century furniture designers. His natural humility means he does not push himself and therefore perhaps has not had the recognition he deserves. Furniture designers, unlike product designers, are not backed up by large teams and, unlike artists, they have no agents. His work is intuitive and instinctive. His design roots go back to the British Arts and Crafts movement of the late nineteenth century. There is a quintessential Englishness to his work and he is not afraid to be individual. He is consistent and mature and understands thoroughly what he is doing. Like all good designers Matthew will continue to produce original designs as he and the world change, and as new materials and techniques appear. I am sure we have not seen his best work yet. He has only recently been given the opportunity to work with real industrial processes through his cooperation with the German manufacturing company Authentics, who commissioned him to design a plastic Wait chair. He has welcomed the opportunity to study and develop the industrialised processes they use and has enjoyed the challenge of a new medium. There is a great need for good design in the mass-production market and Matthew's recent close knowledge of this may well lead to his exploring it further.

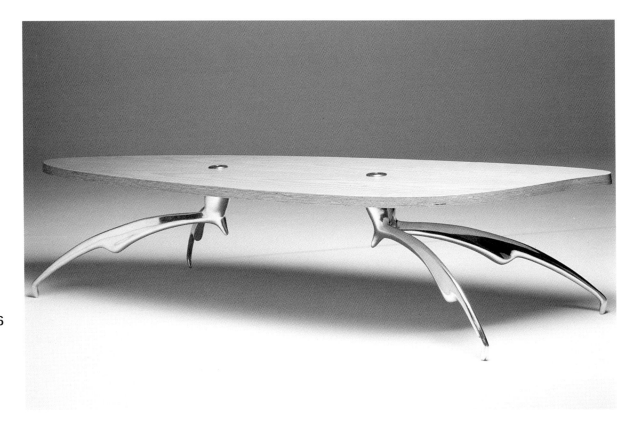

[above]
Surfish table
1989
Sand-cast polished aluminium
legs; veneered plywood top
152 cm
Manufacturer: SCP
Courtesy of SCP

[right]
Kundera table
Designed 1995
Chrome-plated legs; 1.2 cm
toughened glass top
80 cm
Manufacturer: SCP
Courtesy of SCP

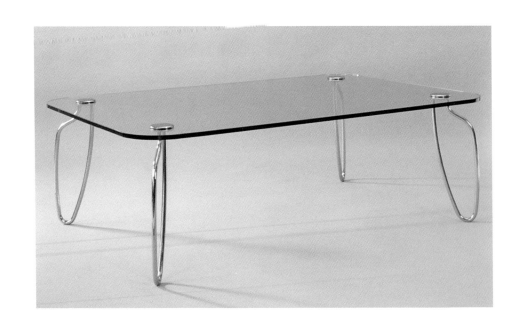

wood

Wood is not a material I am naturally drawn to. If a piece of furniture's most evident appeal is the exploitation and exhibition of the surface of timber, it does not hold much interest for me, nor does the spectacular nature of the hand-crafted, cabinet-made furniture, the main function of which is to highlight the skill of the maker.

40

Luis Barragan
Capuchinas Sacramentarias
del Purisimo
Corazon De Maria Chapel
and Convent restoration
Photo: Armando Salas Portugal
Courtesy of the Barragan
Foundation

[opposite]
David Nash
Cracking Box
1990
Oak
93 x 100 x 97 cm
Courtesy of David Nash

[left]
XO table system
1993
Stained beechwood and glass
Various sizes
Manufacturer: XO
Photo: Tom Vack, courtesy of XO

[below]
Auberon folding dining table
Designed 1990
Solid American oak or cherry
190 cm
Manufacturer: SCP
Courtesy of SCP

The Victoria and Albert Museum acquired Matthew's Antelope table and the set of candlesticks that had led to the original table commission, as well as work by Morrison and Coates. The table showed a quirky juxtaposition of materials: traditionally (at least it seemed so then) down-market MDF, given an exquisite surface by staining, set atop shiny aluminium legs of distinctly zoomorphic appearance. A new sort of tripod table for our own era. It has been shown in our twentieth-century gallery ever since. The candlesticks showed that the most vital design was to be found in everyday, machine-worked materials rather than in the precious metals that many museums (but not consumers) tend to favour.

It would not be fair to speak about Matthew's work as a designer without also mentioning Sheridan Coakley of SCP. Sheridan is, without doubt, the great hero of recent British design and no individual deserves more credit for putting British furniture design on the worldwide map. No designer manages to get things made or marketed without lots of help, prodding, suggestions and problem solving. The journey from drawing or model to manufactured goods is a long one and Matthew has been fortunate to have such a creative partner.

Ten years ago I marvelled at the relative lack of commercial success and attention garnered by Matthew and his colleagues within the UK. Fortunately, retailers and consumers in Europe felt differently and eventually, slowly, British buyers followed suit. Commissions to Matthew from French and Italian manufacturers were forthcoming and it is enormously satisfying that success and recognition have been the result.

45

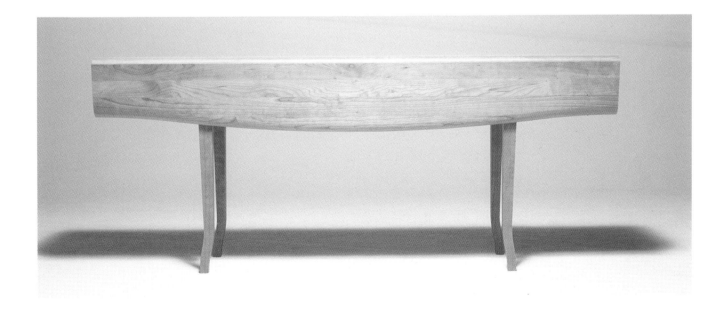

Marcus Field
Former Editor of Blueprint

'He's so English', is the thing everybody says about Matthew Hilton. He must be sick to death of hearing it. All right, he has designed some pared-back timber tables in the Arts and Crafts tradition (I have his Auberon dining table at home – a daily delight), and a leather armchair which would look at home in a gentleman's club. But really, I think there's more to him than that.

When I went to visit Matthew in his studio just before Christmas in 1998, he was busy putting the finishing touches to the plastic chair Wait which he designed for the German manufacturer Authentics (hardly an English classic). A wood-burning stove was blazing and there was a slightly Dickensian feel about the place. There on the shelves was evidence of another Matthew, one we rarely hear about. Books on Rothko, Barragan and Eames jostled with the little white maquettes of the designer's famous pieces. Volumes on a suicidal abstract artist, a formalist Mexican architect and the American champions of mass-produced furniture are hardly seminal texts for a budding Ambrose Heal.

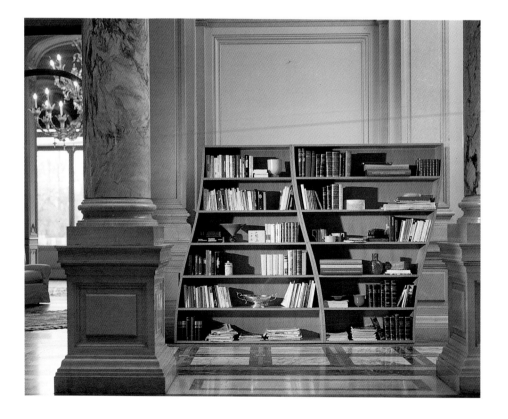

Alterego shelves
1993
Veneered plywood
210 cm
Manufacturer: Alterego
Courtesy of Alterego

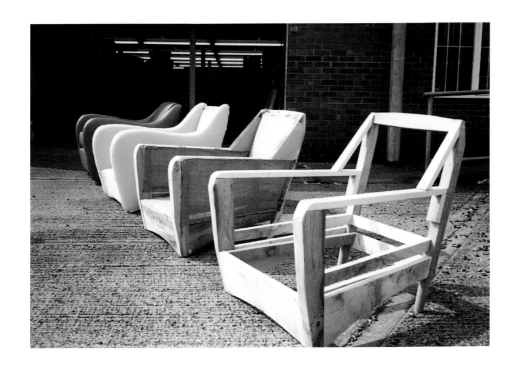

[left]
Balzac armchair in production

[below]
Club armchair (scale model and
prototype)
1991
Beechwood frame, multi-density
foam, stainless steel legs, various
coverings
77 cm
Manufacturer: SCP
Courtesy of SCP

53

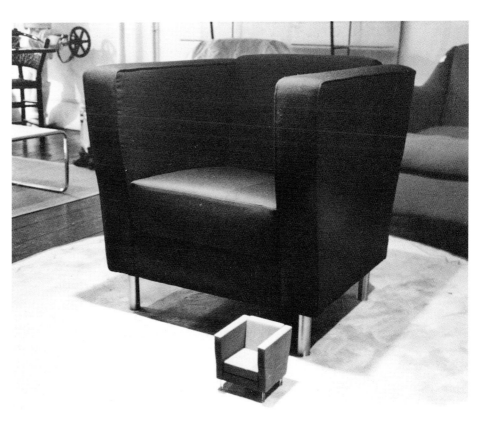

Seth Stein
Architect

If I am looking for an alternative to the twentieth-century classics, such as Eileen Gray, Le Corbusier, and Mies van der Rohe, there are really very few designs to select from that have this simple yet more sensual quality. My architecture for domestic projects aims to achieve a simplicity of form where furniture may be appreciated for its sculptural qualities. My house in London contains a curving cantilevered staircase as part of the main living space and the sinuous lines form a dialogue with the design of the Balzac sofa and armchair.

Balzac armchair
1991
Beech frame, multi-density foam, oak legs, feather cushions, various coverings
98 cm
Manufacturer: SCP
Courtesy of SCP

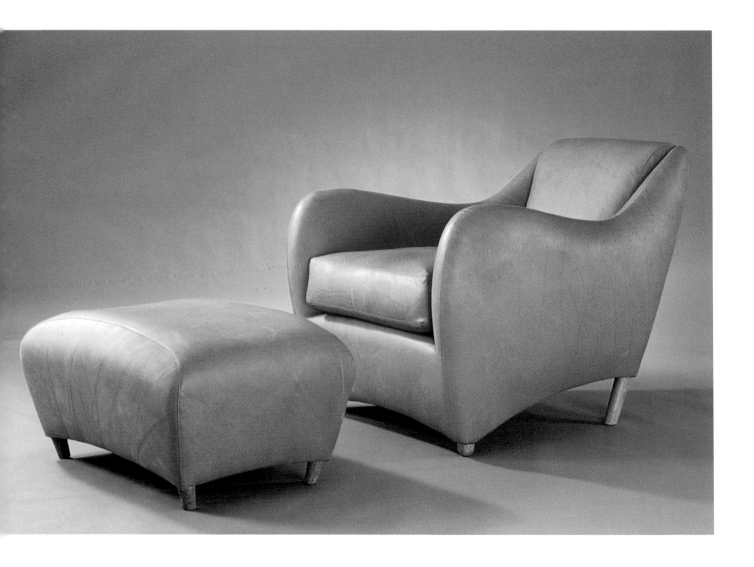

Easy chair
1992
Tubular steel and multi-density
foam, various coverings
72 cm
Manufacturer: SCP
Courtesy of SCP

Enrico Astori
Managing Director of Driade Spa, Italy

Before I actually met Matthew, I had been introduced to a number of his metal objects. These seemed as if they had been worked on by time rather than by a designer: their form and material appeared more like products of sedimentation and attrition, of a wearing down, like stones and pebbles on the seashore.

This conferred on them a sincerity, an emotional immediacy that design all so frequently lacks. Some years later, whilst looking for an organic soul of British design, I wasn't therefore altogether surprised on meeting Matthew to find, in his manner and thoughts, the same aristocratic roughness that had previously struck me about his work. The rounded models perched on legs like soft, padded lunar modules (the result of that first meeting about a new family of seating) confirmed that impression.

56 Together we have produced an initial collection of armchairs and sofas – organically futuristic, yet familiar – in a spirit of co-operation verging on complicity, something rare between designer and producer. We have, in so doing, given the lie to the all-too-common assertion that only conflict can exist between 'art' and 'market'.

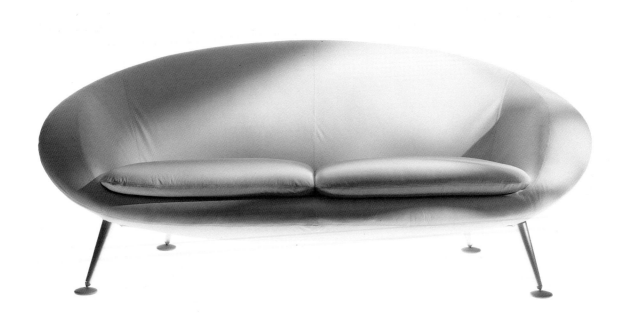

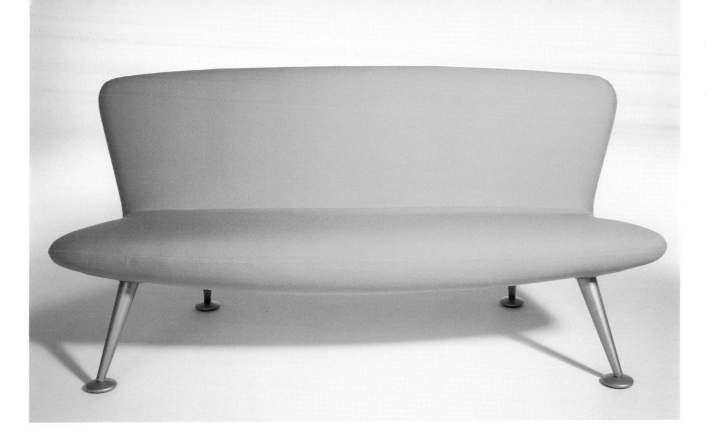

[above]
Gemini bench
1995
Injection-moulded polyurethane
foam (IPF), tubular steel skeleton,
tubular steel legs, leather/cotton
cover
155 cm
Manufacturer: Driade spa
Photo: Tom Vack, courtesy of Driade

[right]
Orion armchair
1995
IPF, tubular steel skeleton, tubular
steel legs, leather/cotton cover
89 cm
Manufacturer: Driade spa
Photo: Tom Vack, courtesy of Driade

[left]
Mercury sofa
1995
IPF, tubular steel skeleton, tubular
steel legs, leather/cotton cover
200 cm
Manufacturer: Driade spa
Photo: Tom Vack, courtesy of Driade

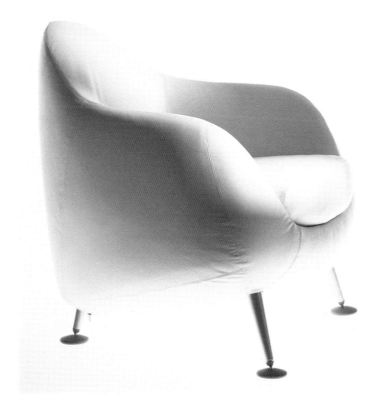

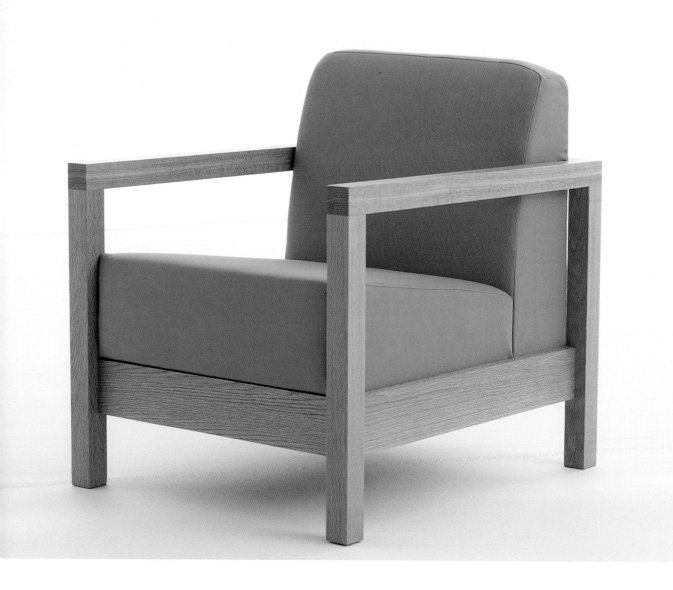

Reading armchair
1993
Solid American oak frame, multi-density foam
75 cm
Manufacturer: SCP
Courtesy of SCP

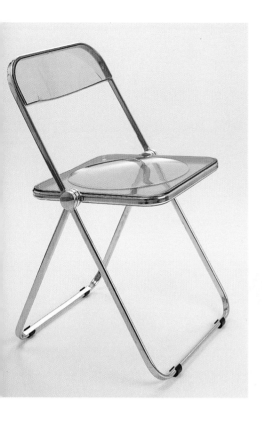

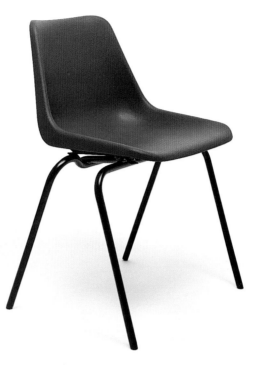

[far left]
Vico Magistretti
Selene chairs
1969
© Fiell International

[centre]
Giancarlo Piretti
Plia chair
1969
© Fiell International

[right]
Robin Day
Polypropylene chair
1962-3
© Fiell International

65

Plastics manufacturing is probably the most mechanised of all the mass-production processes. Products are designed and tested on computer using highly sophisticated programmes and I think plastic is the defining material of the twentieth century, man-made and mouldable to any shape, cheap, strong and light.

Matthew Hilton

plastic: process

Hilton's first design for Authentics, a company near Stuttgart, in Germany, was a clock, completed in 1997. He next approached the Managing Director, Professor Hans Maier-Aichen, and the Technical Manager, Peter Buckwoldt, with his idea for a plastic chair. They expressed interest and by the beginning of 1998, after three months' detailed research, Matthew was ready with his sketch proposals.

Hilton persuaded Authentics to allow him to undertake the design and development with Opius, a UK product and industrial design company, using a computer programme called Pro-Engineer. He made a polystyrene foam model and a drawing from which data was taken to create a computer model. Detailed consideration was made of the injection-moulding process and ten weeks were spent testing the computer model for factors such as strength and weight, ergonomics, the temperature and flow of plastic, and the cycle time of injection moulding.

From the computer data a 3-dimensional model was made by FM Model Makers, carved from a block of chemi-wood using a computer-controlled milling machine. The model was used to test ergonomics further, as well as the aesthetics, and when this design stage was complete, the data was e-mailed to the toolmakers, Ital Stampi in Brescia, Northern Italy. After a further period making minute adjustments, the solid form of the chemi-wood model became the cavity in a solid stainless-steel injection-moulding tool. The tool was made in three parts to fit together like an enormous 3D jigsaw, accurate to thousandths of a millimetre, containing a valve for a high-pressure injection point, copper rods to absorb heat, a honeycomb of cooling channels and ejector pins to push the finished chair out of the mould.

In operation the complete mould is mounted in a machine which hydraulically opens and closes it. The plastic is heated until molten and injected into the cavity at enormous pressure. The plastic is then cooled in the mould, the tool is opened and the chair ejected. This whole automatic process takes fifty-two seconds – as was predicted by the original computer design – using a machine the length of a double-decker bus.

66

[top, left]
Wait plastic chair model
1998

[top, right]
Wait plastic chair (first prototype moulding discussion)
1998-9

[bottom]
Peter Buckwoldt examining the injection-moulding tool
1998

Biography

1957	Born Hastings, England
1975-76	Foundation course Portsmouth College of Art
1976-79	Furniture and Three Dimensional design degree Kingston Polytechnic
1980-84	Worked as industrial designer and modelmaker, designing plastic injection mouldings for casing electrical products, Apricot computer products and retail shops
1984	Set up design studio/workshop designing and producing furniture and shop window displays
1985	First exhibition of furniture designs and cast aluminium accessories: Joseph pour la Maison, Knightsbridge, London
1986	Designed various pieces including Bow Shelves for SCP Ltd London; first show Salone del Mobile, Milan
1986-92	Continued to design and further develop both the furniture and cast aluminium pieces for SCP Ltd
1992 to date	Commenced work for companies outside the UK

75

Hilton Commissions

SCP Ltd, London; Driade, Italy; Disform, Spain; Sawaya and Moroni, Italy; XO, France; Montis, Holland; Perobell, Spain; Authentics, Germany; Handles and Fittings Ltd, England; Lusty's Lloyd Loom, England.

Exhibitions

Abitare Il Tempo, Verona, September 1994
Abitare Il Tempo, Verona, September 1995
British Design, Cologne, January 1997
Houseworks, A multi-discipline contemporary art show, London, April 1997
UK Style, Touring exhibition highlighting all areas of UK design, 1997
Power House UK: The Best of British Design, London, April 1998
Open Urban Picnic, A multi-disciplinary exhibition examining urban regeneration,

76 London, September 1999

Museum Permanent Collections: Victoria and Albert Museum, Geffrye Museum, Manchester City Art Gallery

Contributors

Enrico Astori is Managing Director of Driade spa, Italy. He trained as an architect at Milan Polytechnic University and graduated in 1960. Together with his sister Antonia, an architect, and his wife Adelaide Acerbi, a graphic designer, he founded Driade in 1968. Always more than the average entrepreneur, Astori is also the art director of this avant-garde and innovative company in the design world. He divides his time between Milan and London.

Dinah Casson and Roger Mann established the interior design consultancy Casson Mann in 1984. The practice is currently specialising in museum design with three galleries for the Wellcome Wing at the Science Museum opening in 2000 and fifteen British Galleries at the Victoria and Albert Museum opening at the end of 2001.

Sheridan Coakley is the founder of SCP Ltd which manufactures, produces and retails contemporary furniture and design based at Curtain Road, London. He started in the 1980s, as a dealer in twentieth-century furniture, selling re-editions of furniture by designers such as Mies van der Rohe and Le Corbusier. In 1985 he organised the first exhibition of Philippe Starck furniture and commissioned work by Matthew Hilton, Jasper Morrison, Konstantin Grcic, Terence Woodgate, Andrew Stafford and Michael Marriott.

Sir Terence Conran is one of the world's leading designers, furniture-makers, retailers and restaurateurs. He founded Habitat in 1964 and The Conran Shop in 1973, which now has branches in London, Paris, Germany, Japan and New York. A keen cook and gastronome, he has transformed the experience of eating out in London with his critically acclaimed restaurants which include Quaglino's, Mezzo and Bluebird. He also owns the restaurants Alcazar in Paris, Berns in Stockholm and Guastavino's in New York. In 1993 he formed an architecture and design practice called Conran and Partners which works on all of the restaurants and shops, as well as numerous external projects.

Jane Dillon has been an international furniture designer for the last thirty years. After working with Ettore Sottsass at Olivetti in Milan, she set up a London-based studio in the early 1970s producing work that was to be a significant influence during that period. Clients have included Herman Miller, Cassina, Casas, Habitat and The Science Museum. She is also a Tutor at the Royal College of Art.

Rasshied Din is a well-known designer with a successful interior and graphic design consultancy, Din Associates, which was formed in 1986. Clients have included Nicole Farhi, the Victoria and Albert Museum, Liberty, Habitat, Tommy Hilfiger and The Earl Spencer. In 1990 Rasshied became winner of the Harvey Nichols/*Observer Magazine* Young Business Person of the Year award. He is presently writing a book, *New Retail*, to be published by Conran Octopus in Spring 2000.

Tom Dixon is the Design Director of Habitat.

Marcus Field, formerly a writer and editor of *Blueprint*, the international magazine of architecture, design and contemporary culture, is the Associate Editor at the *Independent on Sunday*.

Konstantin Grcic was trained at the John Makepeace School for Craftsmen in Wood, Dorset, and at the Royal College of Art in London. He founded Konstantin Grcic Industrial Design in 1991 in Munich, Germany working for an international industry in the fields of furniture, product and lighting design.

78

Geoff Hollington founded the design firm Hollington in 1980. It has become one of the world's leading product and interaction design consultancies. Products designed by Hollington have won international awards and are in museum collections. Clients include Parker Pen, Herman Miller, Eastman Kodak, Gillette, Caradon Plumbing Solutions and the Science Museum, London.

Professor Hans Maier-Aichen became a consultant for cultural affairs at the European Community, Brussels from 1978-81 after a successful career in design on his own account. In 1980 he created the manufacturing company Authentics for mass-production design. Economy and ecology are the firm's most important objectives and they were awarded the European Design Prize in 1997. In 1999 he was appointed Professor at Central Saint Martins College of Art at the London Institute and he is also member of the Presidential Board of the German Design Council.

Seth Stein Architects was established in 1989 in London. Completed projects include new-built houses in Central London and numerous loft spaces. Overseas they are working with completed houses in Finland, Canada and work in progress in South Africa. Their public commissions include a Pocket Park in the City of

London and refurbishment and additions to the Harewood House stable in Yorkshire that will provide an art gallery and a restaurant.

Paul Thompson is Director of the Design Museum in London. Before joining the Design Museum he worked at the government agency, the Design Council. He has a PhD in Modern European Thought from the University of East Anglia.

Michael Warren is the Course Director for undergraduate studies in the School of 3D Design at Kingston University.

Christopher Wilk is Chief Curator in the Department of Furniture and Woodwork at the Victoria and Albert Museum. He is also the author of books on Thonet, Marcel Breuer and Frank Lloyd Wright.

Gareth Williams is Assistant Curator in the Department of Furniture and Woodwork at the Victoria and Albert Museum. He is currently on secondment as the V&A Exchange Fellow at the University of Sussex in Brighton, sharing his time between there and the Research Department at the Victoria and Albert Museum. **79**